CREATIVE

BLOCK

A book of 118 tasks which aim to begin the motions of
experimentation and conceptualisation.
Push boundaries, leave the box behind, and figure out what on
earth creativity even is any way.

For creatives and non-creatives alike.

With very special thanks to the kid's club that inspired this idea, my wonderful friend Becca for her expert advice and to everyone who supported the book.

When you need a kickstart, to unwind, to enjoy or simply get the juices flowing, some days are harder than others.

Artist's/Writer's/Sculptors/Designer's/All-round-creative's block, or whatever you want to call it, has been the frustration of many.

Those who say they don't get it, are simply lying.

This book is here to combat that, and open your eyes to different ways to conceptualise and create, far far away from the traditional, mainstream or ordinary.

Every project has a theory behind it, which you can learn more about, and how to apply it in future processes at the back of the book.

All-in-all, this book is for fun, experimenting and definitely pushing on those boundaries, our own little anarchy!

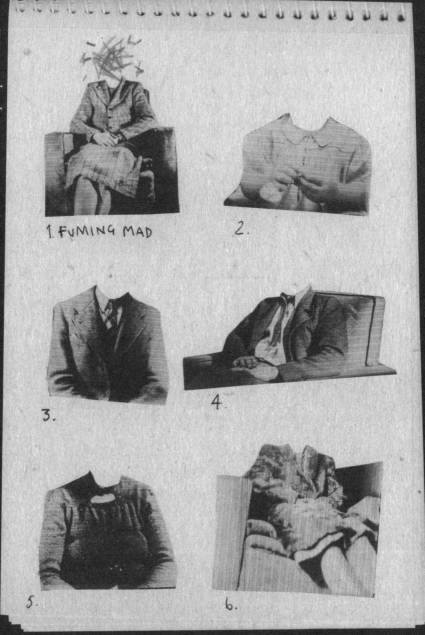

1. FUMING MAD

2.

3.

4.

5.

6.

1. Show the emotions of these people in their heads
using only shapes, colours and abstract squiggles.

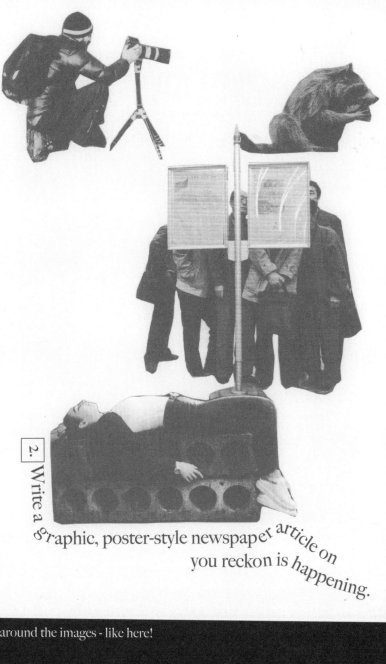

2. Write a graphic, poster-style newspaper article on you reckon is happening.

Write around the images - like here!

3. Cut out these letters, then stick back down onto a contrasting colour, allowing for them to twist, arch and bow. View from above and experiment with the distortion.

4. Take a bold typeface, then cut
it up into slices and rearrange.

5.

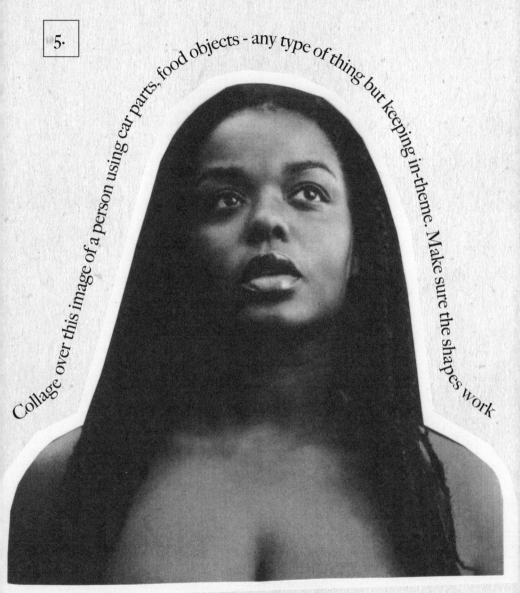

Collage over this image of a person using car parts, food objects - any type of thing but keeping in-theme. Make sure the shapes work

with those on the person - e.g. a car bonnet for the forehead.

Don't edit shapes to fit - they
need to do so naturally!

6. Get your favourite typeface or logo and hand-draw it. As big as you possibly can (bigger than this).

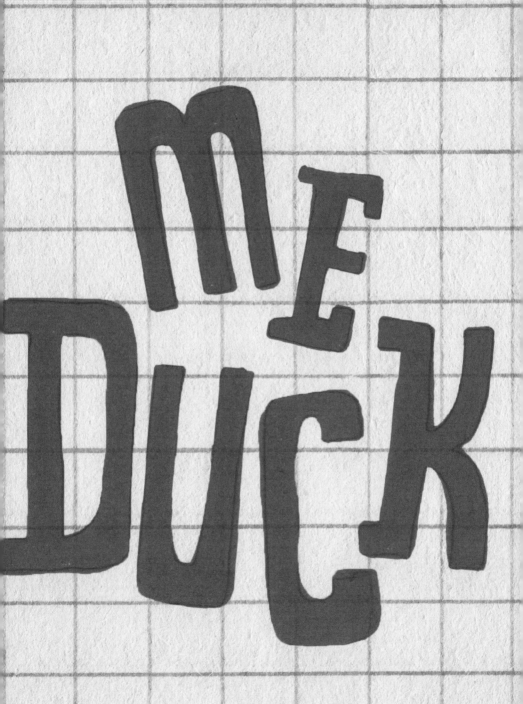

↳Retro Serif Regular.

7. Wet these sections from basically dry to sopping.
 Then drip ink onto them, in varying amounts.

1 2 4 3 5

8. Give these numbers their own personalities, based on how you perceive them. Always felt like 4 looks a bit snooty myself.

6 7
8
9
0

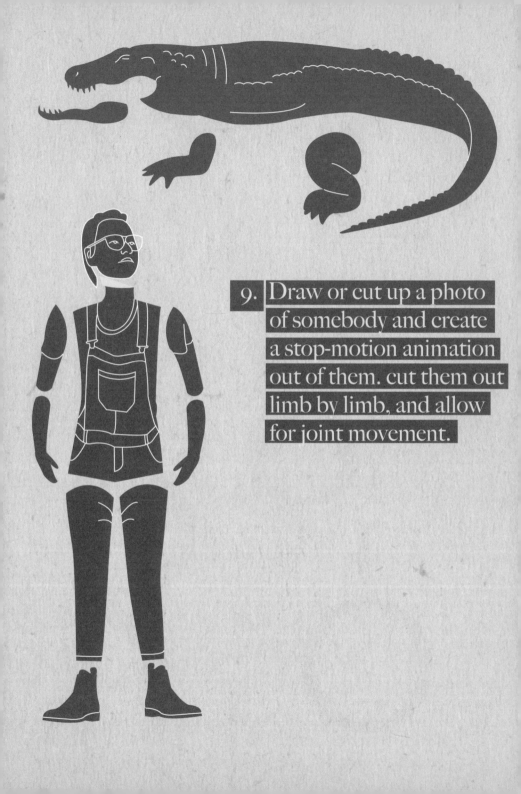

9. Draw or cut up a photo of somebody and create a stop-motion animation out of them. cut them out limb by limb, and allow for joint movement.

10. Translate the alphabet into a colour per letter.
Then translate this page into dots of colour.

a =	f =	k=	p=	u=	z=
b =	g =	l =	q=	v=	
c =	h =	m =	r =	w =	
d=	i=	n=	s=	x=	
e=	j=	o=	t=	y=	

"When you need a kickstart, to unwind, to enjoy or simply get the juices flowing, some days are harder than others.

Artist's/Writer's/Sculptors/Designer's/All-round-creative's block, or whatever you want to call it, has been the frustration of many.

Those who say they don't get it, are simply lying.

This book is here to combat that, and open your eyes to different ways to conceptualise and create, far far away from the traditional, mainstream or ordinary.

Every project has a theory behind it, which you can learn more about, and how to apply it in future processes at the back of the book.

All-in-all, this book is for fun, experimenting and definitely pushing on those boundaries, our own little anarchy!"

Yes, it's the intro again.

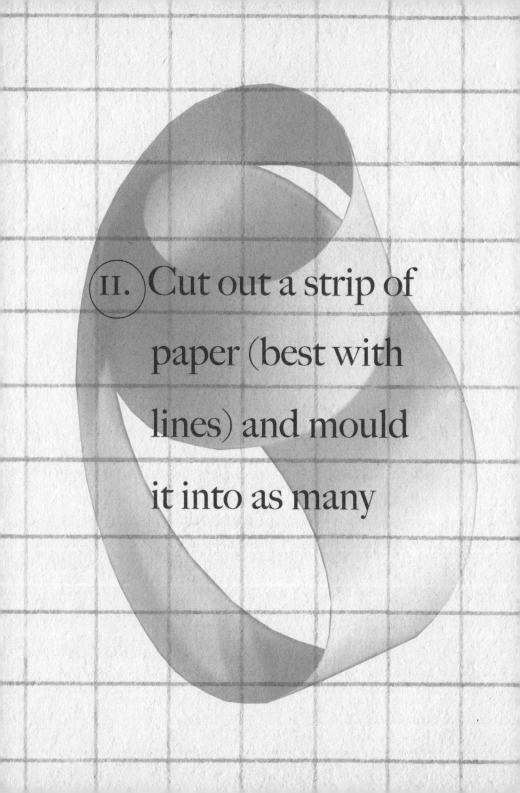

(II.) Cut out a strip of paper (best with lines) and mould it into as many

shapes as possible,
without cutting or
tearing the strip.
Draw them.

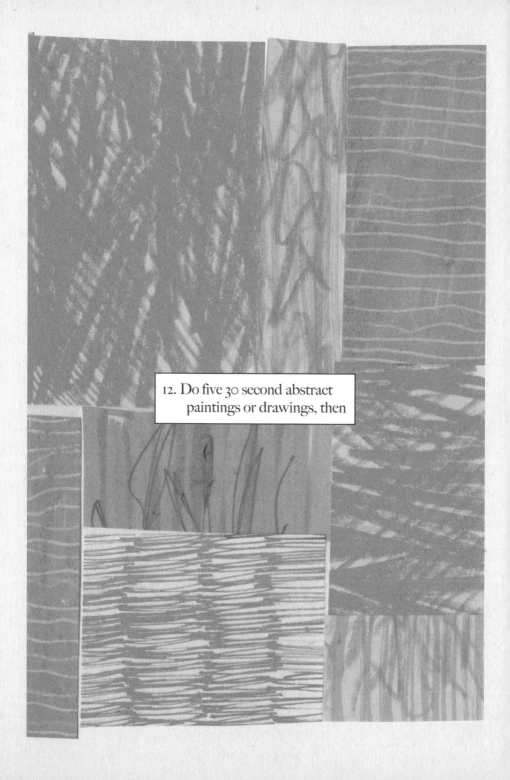

12. Do five 30 second abstract
paintings or drawings, then

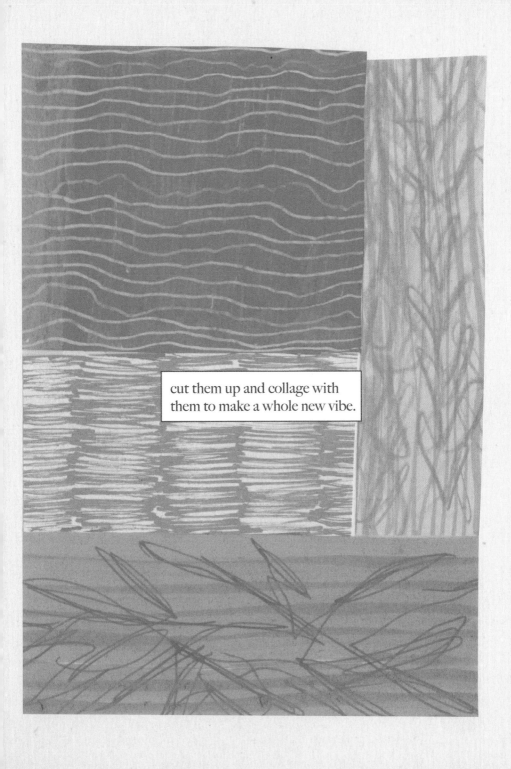

cut them up and collage with them to make a whole new vibe.

13. Pixelate an image, extract out five

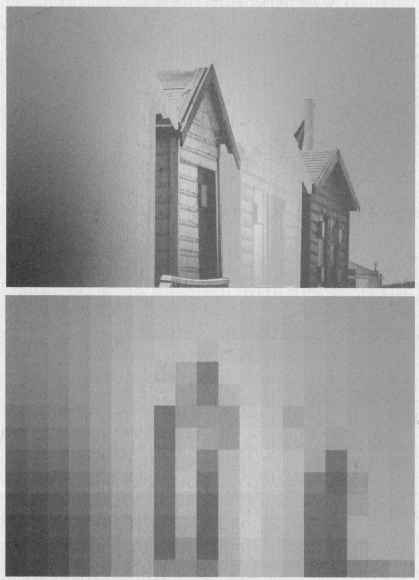

colours, and make a logo with them.

14. Make your own brushes from herbs, feathers, thread etc., and paint a sheet of paper with them. Experiment with the textures.

15. Make the alphabet out of household objects or other nearby items.

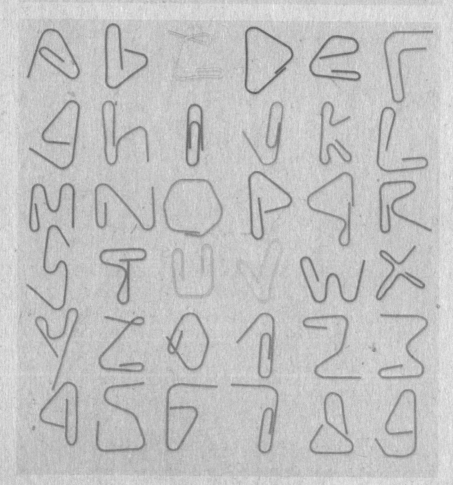

16. Turn these circles into something, maybe a solar system or a house with balloons... You do the creating.

17. Cut out each object (make as many incisions as needed) and then create an image using the leftover pieces. Also, create a very weird vanitas with the actual ones. Celebrating the life of someone you know.

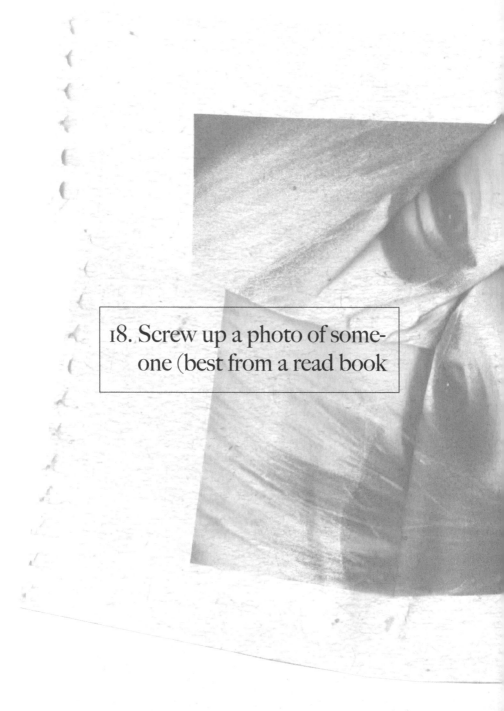

18. Screw up a photo of some-
one (best from a read book

or magazine, to save family
photos) and draw it.

←——For example.

19. Create 8 different variations of the letter 'A' using this square grid.

And on this one, do 2 more letters you just particularly like.

20. Create a collection of four abstract prints
out of the shapes below
and make them all fit a certain
movie released this year.

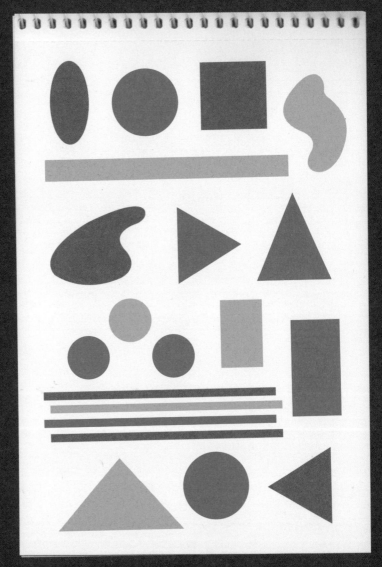

Try to use each shape only once.
Keep it minimal.

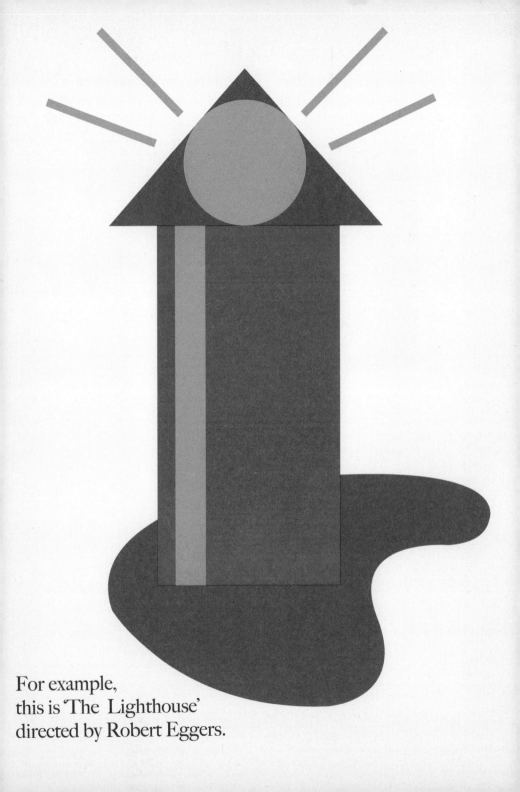

For example,
this is 'The Lighthouse'
directed by Robert Eggers.

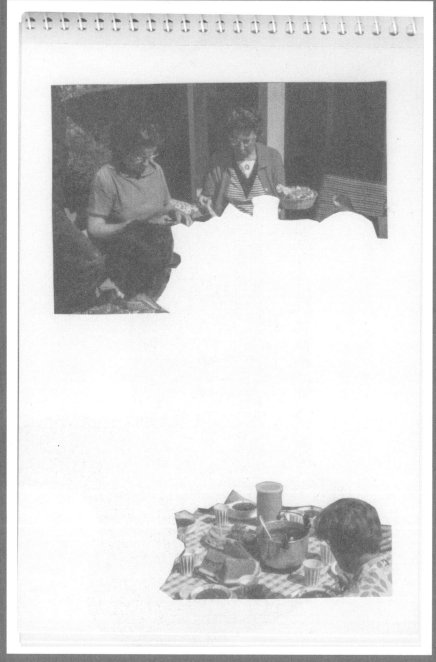

For example, the family could be gazing down at a miniature, living city they
control, and the table could be surrounded by investigators. Maybe.

Fill

a page up

with 2 colour

drawings

of

objects you see

during your

morning

routine.

in any place, and then expressively

23: Blob some paint colours onto some pages

drag a knife or ruler through them, only

once. See what you get.

24. Take a page from a magazine or book and scan
 it, moving and following the scan bar as you go.

25. Cut out the most simple version of an animal
that you imagine in your head. Mind your fingers.

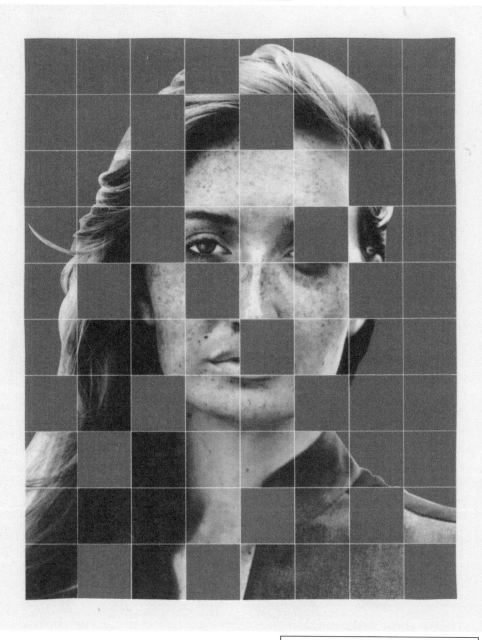

27. Draw the next 2 Instagram posts you see as part of a graphic novel.

Fill these bubbles in with details of an event **either** happening near you or one you'd like to **host**

29. Take photos on film.

Focus on interesting light, colours, shapes.

Then water damage it.

Then get it developed.

30. Draw only the bit in this section.
Scale it up to A3.

31.

Do an observational drawing

but only draw and colour

the shadows.

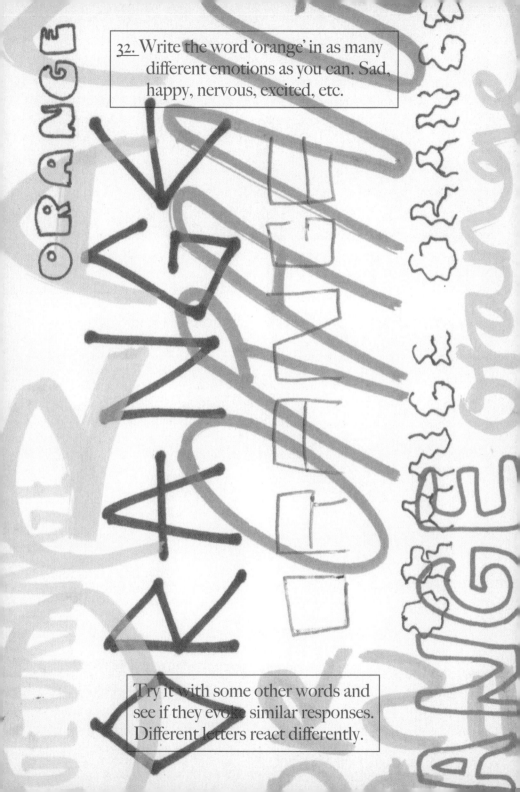

32. Write the word 'orange' in as many different emotions as you can. Sad, happy, nervous, excited, etc.

Try it with some other words and see if they evoke similar responses. Different letters react differently.

33. Use an old pen (running out) and create a textural piece - really explore all the extra lines you get from the fibres in the nib.

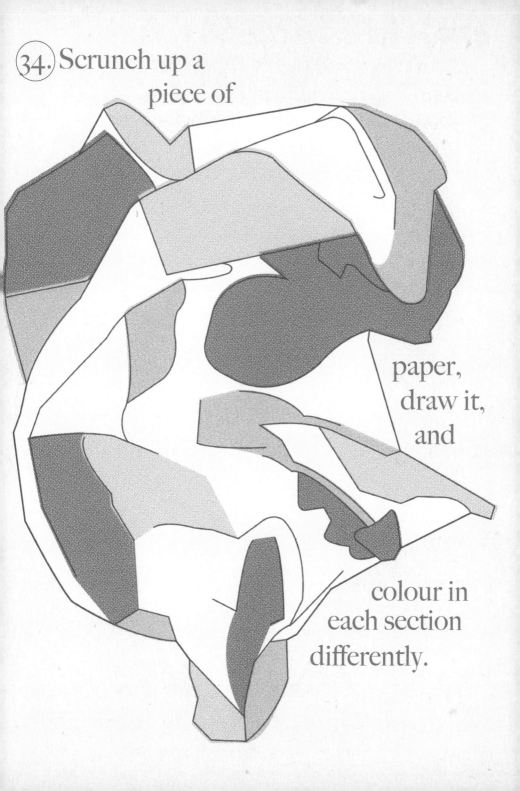

34. Scrunch up a piece of paper, draw it, and colour in each section differently.

35 Make a print out of vegetables and fruit (cross sections are best) to create a print that's nothing to do with veg. For example, mushroom gills look like jellyfish, etc.

36. Create a layered image using a highlighter or a pen with a translucent quality. Go over already drawn areas for darker pitch!

37. Draw an image 3 times; super zoomed out, regular and close up. Can be what you're looking at right now, your town square, whatever. Then cut them into 3, muddle them and replace them together.

38. Create an eye-catching type graphic to match with an image you find. Use one word.

TAKE A
PHOTO
AND
MAKE IT
INTO
A RADICAL

FEMINIST
GUERRILLA-STYLE
POSTER
(LIKE
THIS)

Rachel Young, Collection of Aerial Shots on Google Earth.

'Pictured: The Google Earth alphabet found in Britain's hedgerows, roads and buildings', Marcus Dunk for MailOnline, 7 July 2009. https://www.dailymail.co.uk/news/article-1197898/Pictured-The-Google-Earth-alphabet-Britains-hedgerows-roads-buildings.html

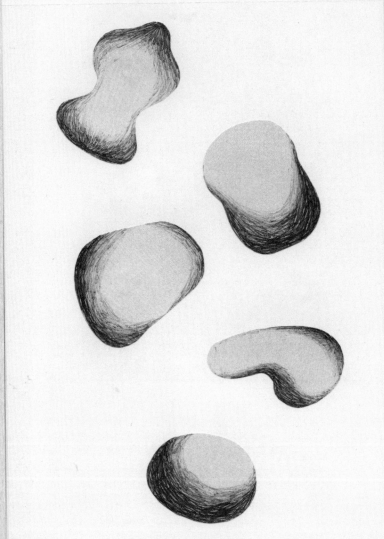

41. Using these 5 shapes, create as many abstract portraits of things / people as you can. Shading can be used to help guess what it is.

Get experimental.
This is a nose, perhaps.

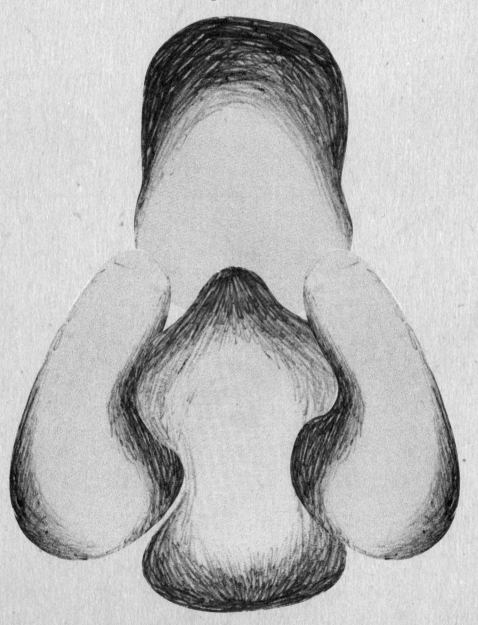

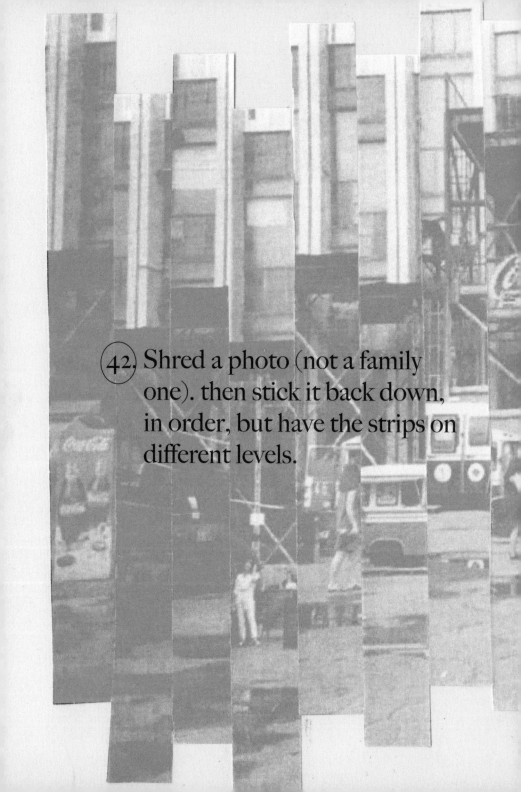

42. Shred a photo (not a family one). then stick it back down, in order, but have the strips on different levels.

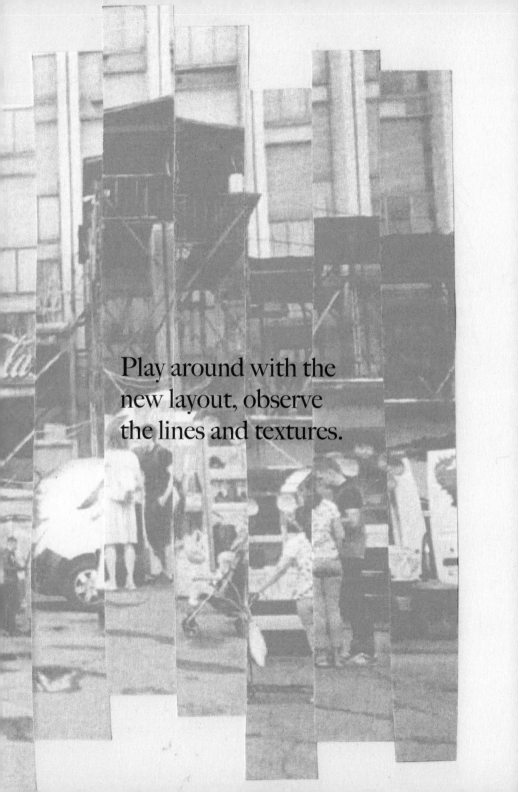

Play around with the
new layout, observe
the lines and textures.

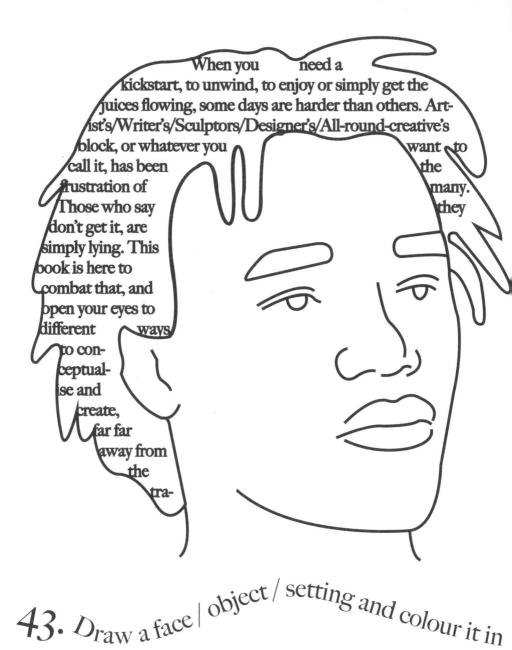

When you need a kickstart, to unwind, to enjoy or simply get the juices flowing, some days are harder than others. Artist's/Writer's/Sculptors/Designer's/All-round-creative's block, or whatever you want to call it, has been the frustration of many. Those who say they don't get it, are simply lying. This book is here to combat that, and open your eyes to different ways to conceptualise and create, far far away from the tra-

43. Draw a face / object / setting and colour it in smaller type being lighter, and larger,

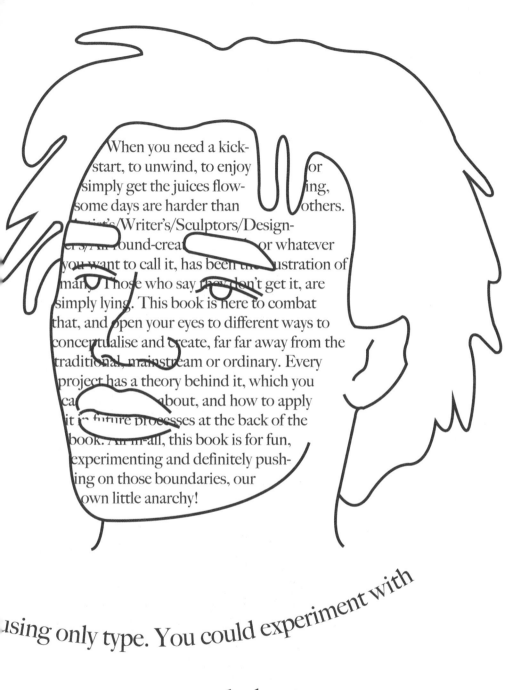

When you need a kick-start, to unwind, to enjoy or simply get the juices flow-ing, some days are harder than others. Artist's/Writer's/Sculptors/Design-ers/All round-creatives or whatever you want to call it, has been the frustration of many. Those who say they don't get it, are simply lying. This book is here to combat that, and open your eyes to different ways to conceptualise and create, far far away from the traditional, mainstream or ordinary. Every project has a theory behind it, which you can read about, and how to apply it in future processes at the back of the book. All in-all, this book is for fun, experimenting and definitely push-ing on those boundaries, our own little anarchy!

using only type. You could experiment with

thicker type being darker in tone.

44.

Draw how you think these shapes would look as topographs.

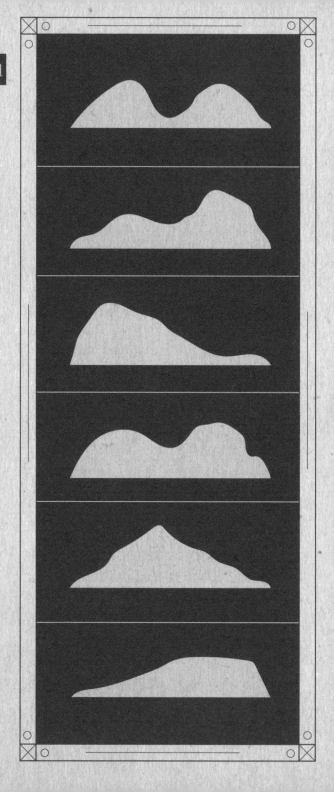

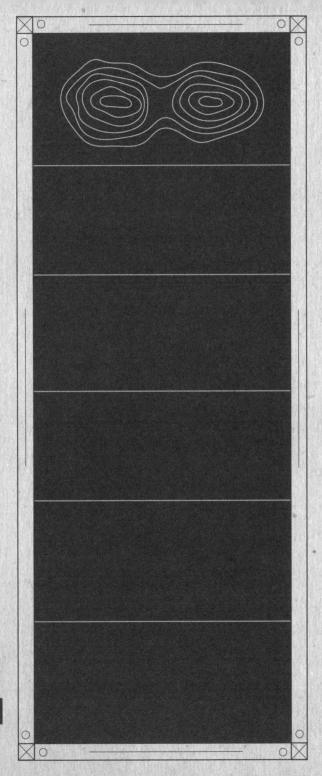

Then make
something
out of those
drawings.

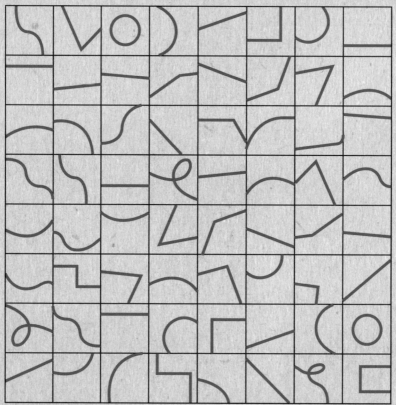

45.

Cut-out / copy out these
tiles and re-arrange them
to form a new shape or
image.

46. Turn the shape of this image into something else.

Do this to any image you see.

EXAMPLE

EXAMPLE

Join up the words following the paths.

BEND

BEND

DIMENSION

DIMENSION

Try this yourself with your own words.

DISTORT

DISTORT

Using only your initials,
create a letter-press
style self-portrait.
(Customise as you
wish)

I reckon you could
pop one like
this on a
coin.

48.

the centre until they all meet.

Make something with the print.

They can join, but not overlap.

50.

Create a direct visual metaphor.

Paste two images together.

51.

Cecilia Chapman 711-2880 Nulla St. Mankato Mississippi 96522 Cecilia Chapman Cecilia Chapman 711-2880 Nulla St. Mankato Mississippi 96522 Cecilia Chapman 711-2880 Nulla St. Mankato Mississippi 96522 Cecilia Chapman 711-2880 Nulla St. Mankato Mississippi 96522 Cecilia Chapman 711-2880 Nulla St. Mankato Mississippi 96522 Cecilia Chapman 711-2880 Nulla St. Mankato Mississippi 96522 Cecilia Chapman 711-2880 Nulla St. Mankato Mississippi 96522 Cecilia Chapman 711-2880 Nulla St. Mankato Mississippi 96522 Cecilia Chapman 711-2880 Nulla St. Mankato Mississippi 96522 Cecilia Chapman 711-2880 Nulla St. Mankato Mississippi 96522 Cecilia Chapman 711-2880 Nulla St. Mankato Mississippi 96522 Cecilia Chapman 711-2880 Nulla St. Mankato Mississippi 96522 Cecilia Chapman 711-2880 Nulla St. Mankato Mississippi 96522 Cecilia Chapman

Draw the outline of your own set of keys but using your address as the lines.

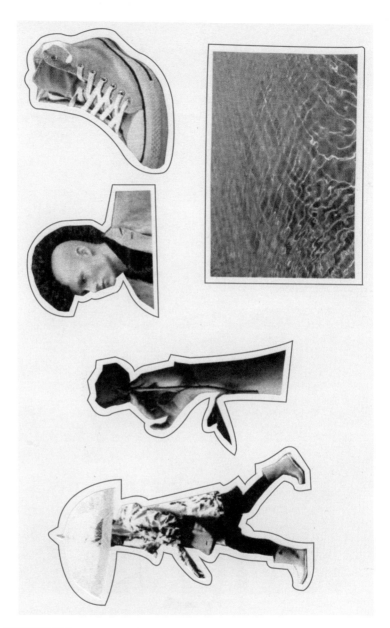

52. Write down one word responses to what these images
evoke for you. then create a scene using them
in one of these three themes:
· Utter despair
· Excitement, and naughtiness
· Danger! Fear!
How will these images be relevant, how will they convey
the emotions you link them to relevantly in this scene?

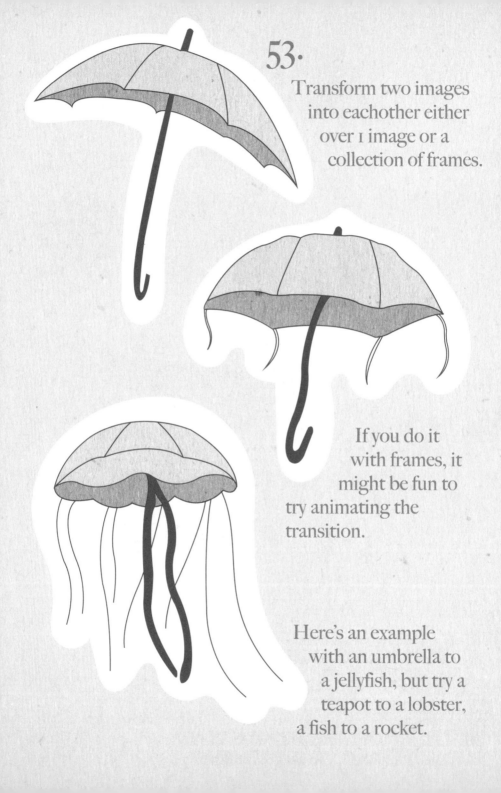

53.

Transform two images
into eachother either
over 1 image or a
collection of frames.

If you do it
with frames, it
might be fun to
try animating the
transition.

Here's an example
with an umbrella to
a jellyfish, but try a
teapot to a lobster,
a fish to a rocket.

54.

(An eye, a person spinning at high speed) Blob paint onto this page. Then sweep it round in a circle with a wide brush. Turn it into something.

55. Fill in the boxes of 6 days (weeks if you're brave) of a piece of fruit rotting

Do another one here. Observe the change in shape, texture...

56. Cut squares of paper and fold them into as many different angles and layers as you can. Stick them onto some paper.

What could this even be?

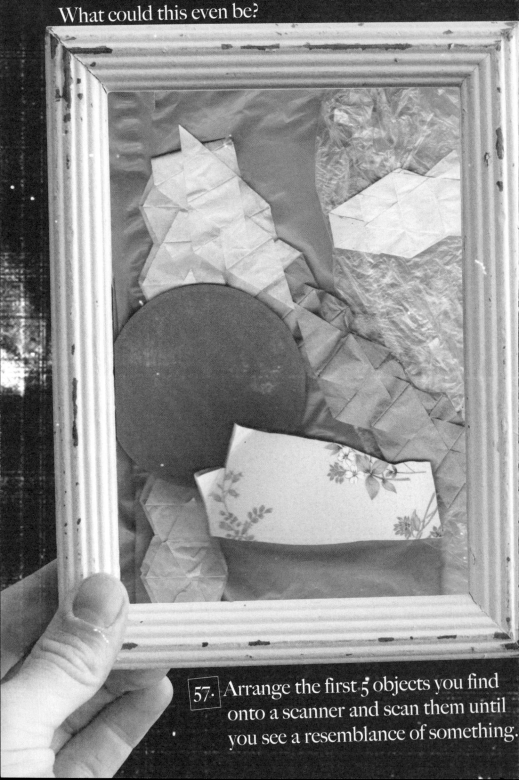

57. Arrange the first 5 objects you find onto a scanner and scan them until you see a resemblance of something.

LEAVE THE BOX BEHIND

58. Draw a set of wavey lines. Then fill them in with hand-drawn type of a phrase you love.

glasses

bike

59. Turn these two circles into as many different things as you

can think of, e.g. glasses, a bike... Cheeky things... You do you.

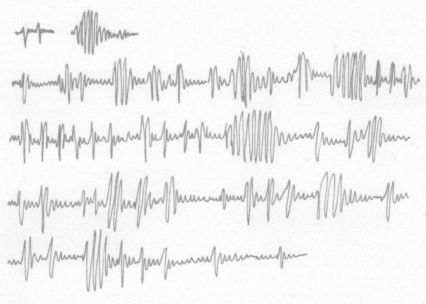

[segments of 'Dreams, Fleetwood Mac]

Turn your favourite song

into soundwaves (more

intense sounds - more vigorous

lines) - then set this

into a letter format. For

whoever will appreciate it.

61.

Using a page from
a book, turn the
words into abstract
shapes like above.
Then make a visual
story out of them.

Draw inside each box as it instructs you, based on your surroundings currently or favourite ones you can look up.

DRAW AN OBJECT
NORMAL SIZE

DRAW AN ANIMAL.
SUPER CLOSE UP

eg fur, scales

DRAW A LANDSCAPE
VERY ZOOMED OUT

DRAW A PANORAMIC

DRAW A BIRD'S EYE
VIEW OF YOUR SPACE

DRAW A CLOSE UP OF
SOMETHING FAR AWAY

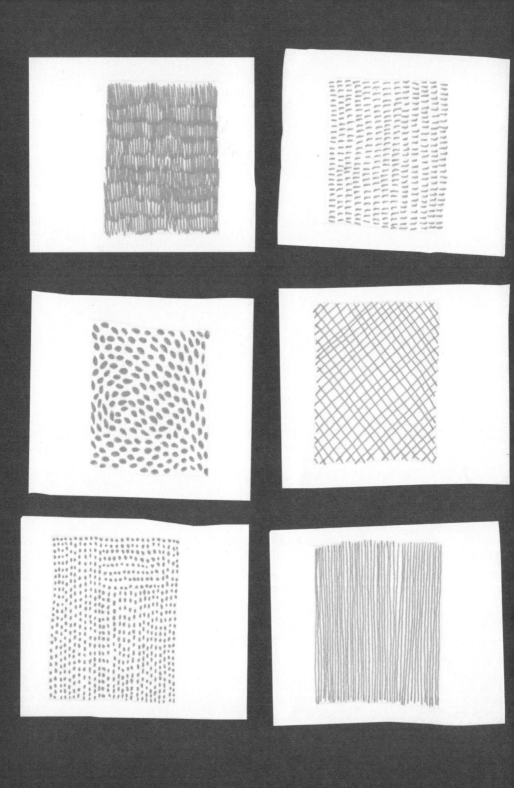

63. Draw a copy of this image but only using the given textures / lines provided.

64.

Create a
micro-
environment
by
drawing
mini

people
onto
these

objects.
Make it
make

sense.

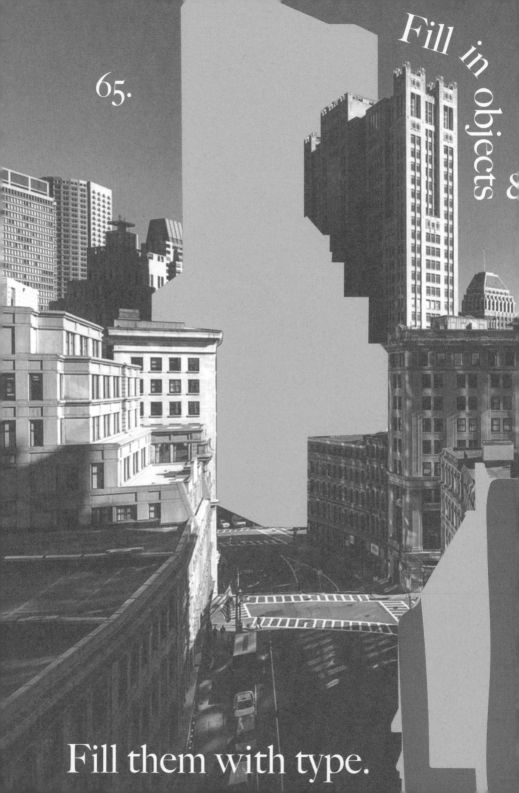

65.

Fill in objects &

Fill them with type.

buildings in images as a block colour.

KETHIS

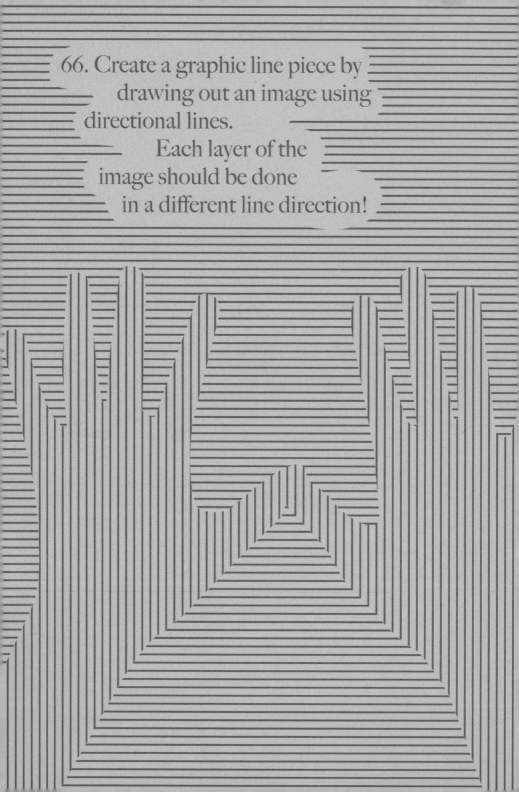

66. Create a graphic line piece by drawing out an image using directional lines. Each layer of the image should be done in a different line direction!

 67. Using iconic graphic logos or shapes, create the image of an iconic character.

Here's Tweety, created using the McDonald's™, Toyota and Spotify® logos.

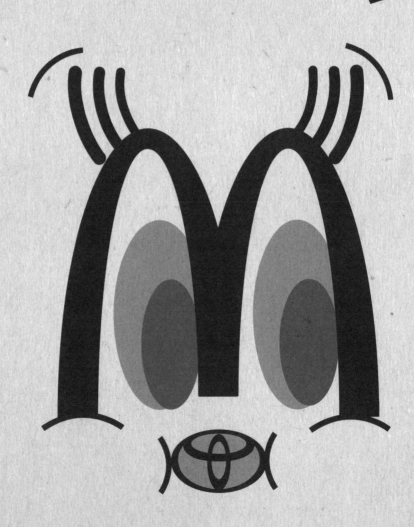

68. Fill these boxes with the most basic silhoutte of

Bow-tie	Croissant	Flag	Grapes
Firework	Hippo	Candle	Boat
Desk lamp	Spider plant	Shoe	Mountain

Fusilli	Kettle	Hat	Pizza
Ladder	Caterpillar	Apron	Lemon
Martini	Maple leaf	Footprint	Glasses

the object named in them.
Only use straight lines.

Paint big sweeping brush strokes using thin paint or ink.

69.

Create letters or figures from them, once dry.

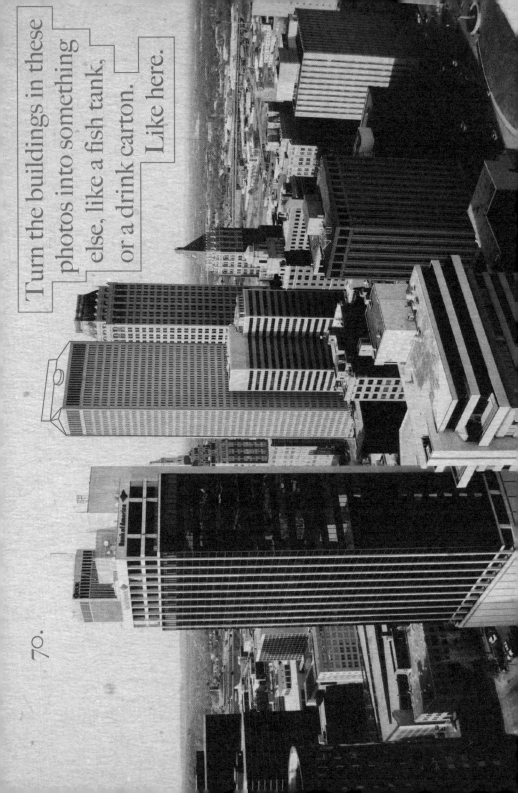

Turn the buildings in these photos into something else, like a fish tank, or a drink carton. Like here.

70.

You could also play about with the shape of the sky as well if you like.

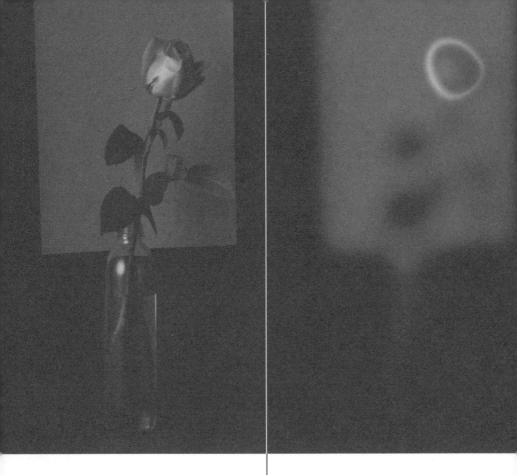

71. Blur an image so **much** you can't really tell **what** it is.

Then draw / paint **it.**

Example **above.**

72. Fill a sketchbook with
 double-page spreads
 of opposites.

73.
Using a single sheet of paper,
fold different angles to create
an abstract image of a scene,
a building, or even just
an abstract object.

74.

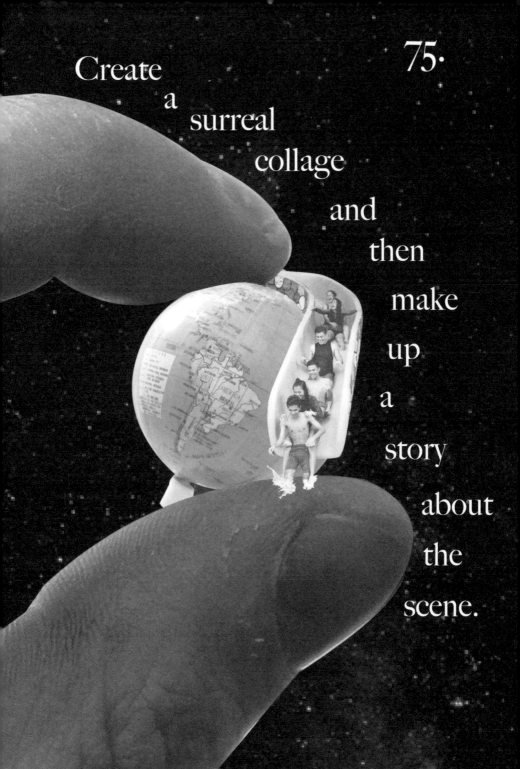

75.

Create a surreal collage and then make up a story about the scene.

Create a piece solely out of tape. You can cut it, tear it, and use different colours and layers.

76.

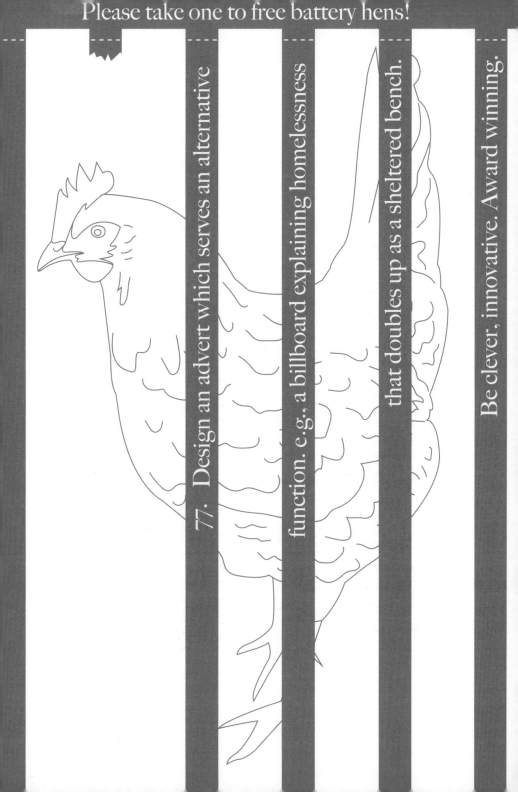

77. Design an advert which serves an alternative function. e.g., a billboard explaining homelessness that doubles up as a sheltered bench. Be clever, innovative. Award winning.

78. Make a portrait or an image out of only letters / numbers. You can use stamps, a typewriter, or do it digitally. Create tone with the harshness / lightness of each glyph. Here is a torso I made earlier.

79.

Crudely cut out shapes of the

things in your surroundings and

recreate the setting on a page.

80. Fold a piece of paper in different ways and
 burn / dye the edges. See what patterns
 you create.

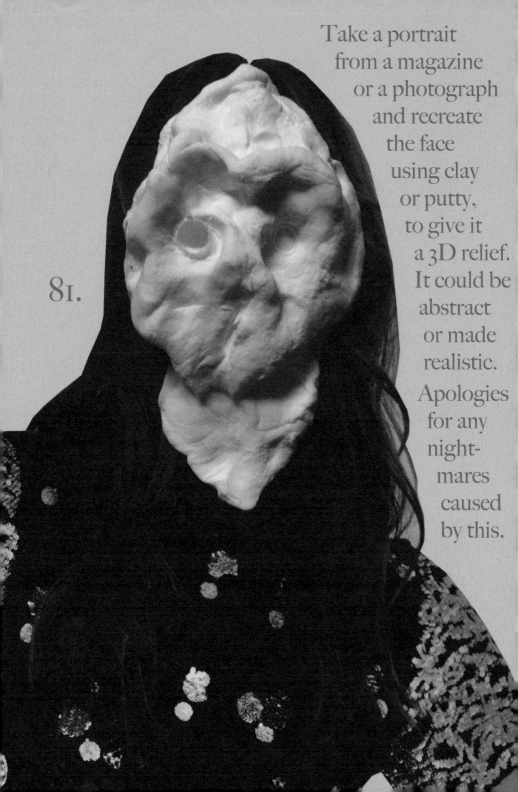

81.

Take a portrait
from a magazine
or a photograph
and recreate
the face
using clay
or putty,
to give it
a 3D relief.
It could be
abstract
or made
realistic.
Apologies
for any
night-
mares
caused
by this.

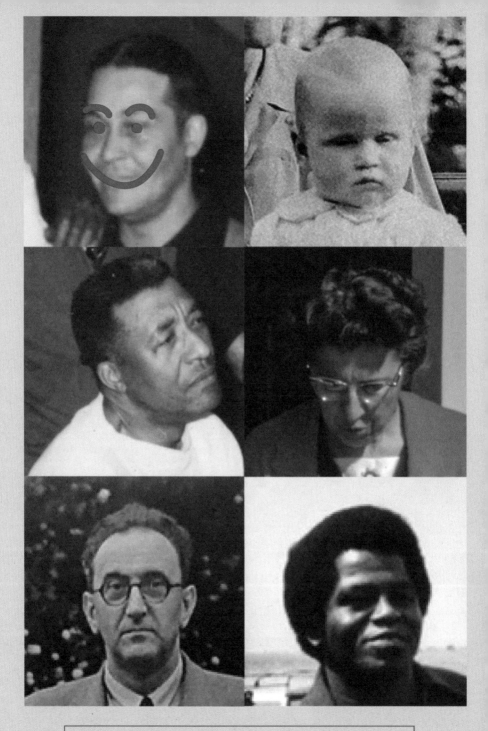

82. Turn these faces into basic emoticons.

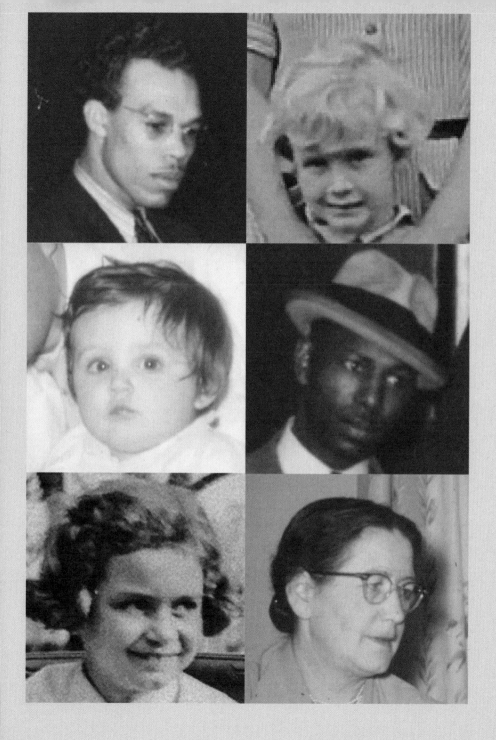

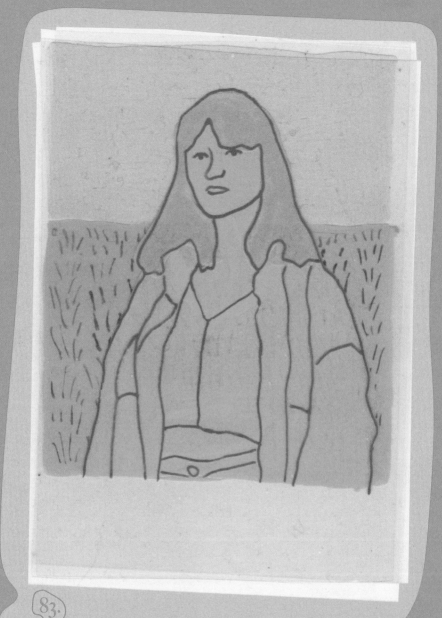

(83.)

Using tracing paper / acetate, fold or cut into 4 pieces and create a four-layered image, filling each section into a different aspect or layer of the image, e.g. the background, clothing, etc.

84. Draw or write onto an inflated balloon. Deflate it. Draw the result.

Using the first 4 household objects you find as

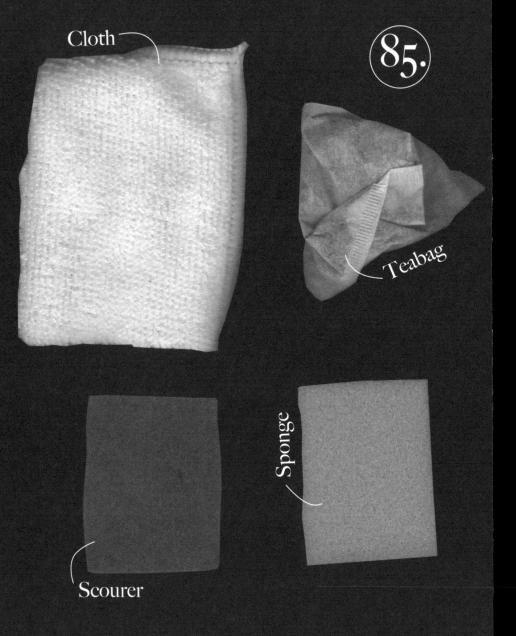

Cloth

85.

Teabag

Sponge

Scourer

stamps, create a print of a landscape or still life.

Sponge

Teabag

Scourer

Cloth

86. Find 4 random words (scroll through insta, one per page in a book) and draw them as how you interpret their dictionary definitions.

For example:

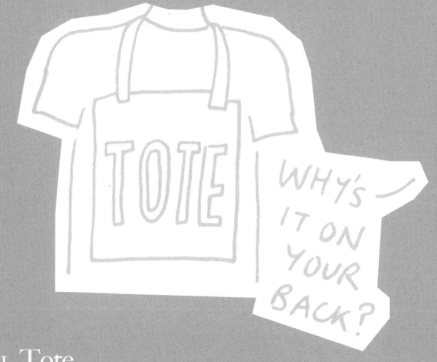

1. Tote

To carry, as on one's back or in one's arms.

2. Rare

Coming or occurring far apart in time; unusual; uncommon.

3. Talk

To communicate or exchange ideas, information, etc., by speaking.

4. Crystal

A clear, transparent mineral or glass resembling ice.

87. Collect one item a day in a book for a week.

They can represent each day or be completely irrelevant.

Then create a story / film plot from these objects.

Play with storytelling. Be entising.

88.

Out of only food items, fill in this stencil of the words 'grubs up'.

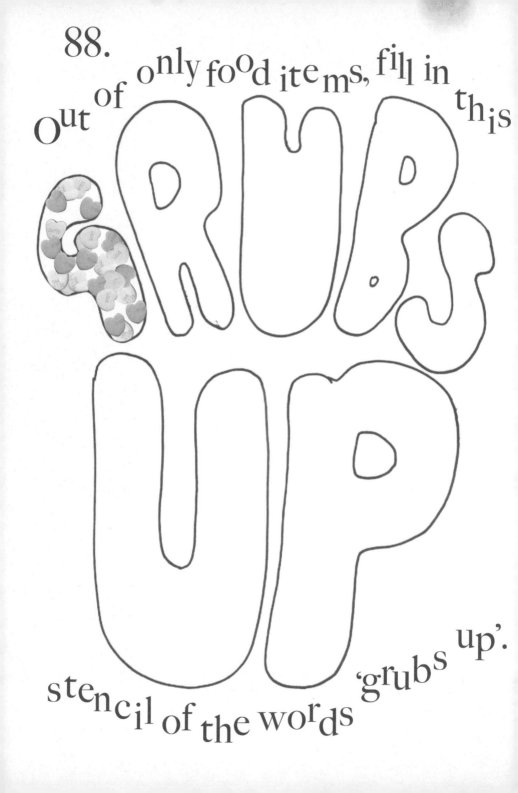

89. Create a surreal image out of 2 things which are completely unrelated. Such as this turtle with a monstera leaf shell, or a dolphin coming out of a banana.

90. Create a simple yet provocative
poster for a charity of your choice.

THEN DAMN IT,
SHARE
IT WITH THE

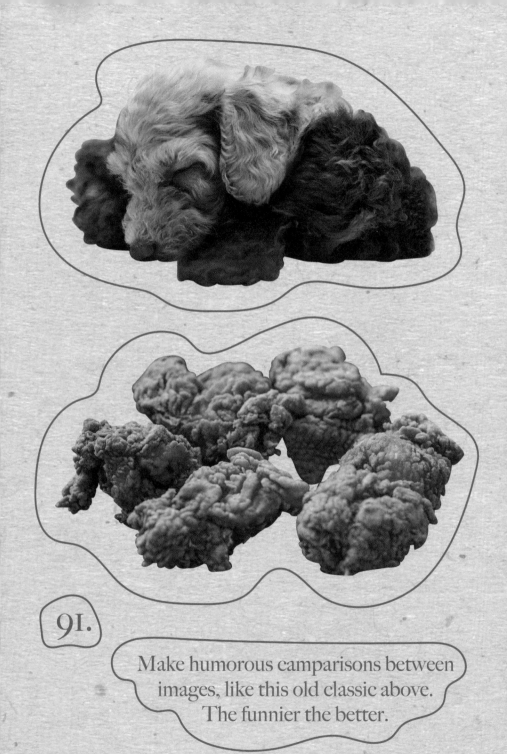

91.

Make humorous camparisons between
images, like this old classic above.
The funnier the better.

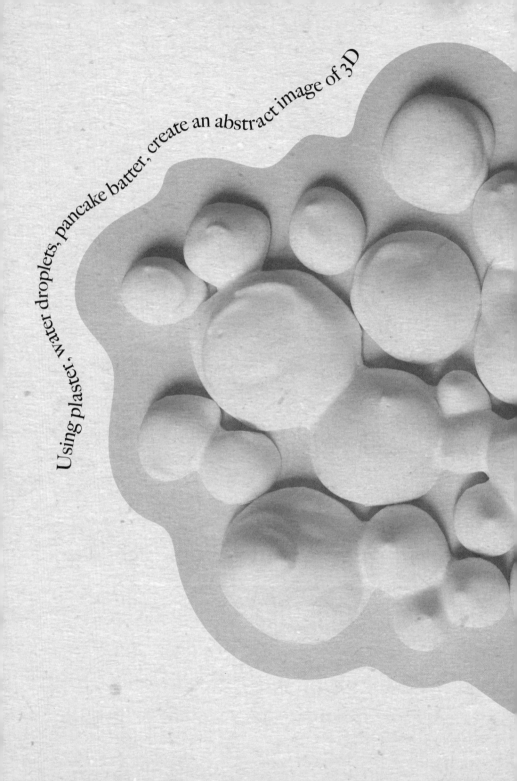

Using plaster, water droplets, pancake batter, create an abstract image of 3D

92.

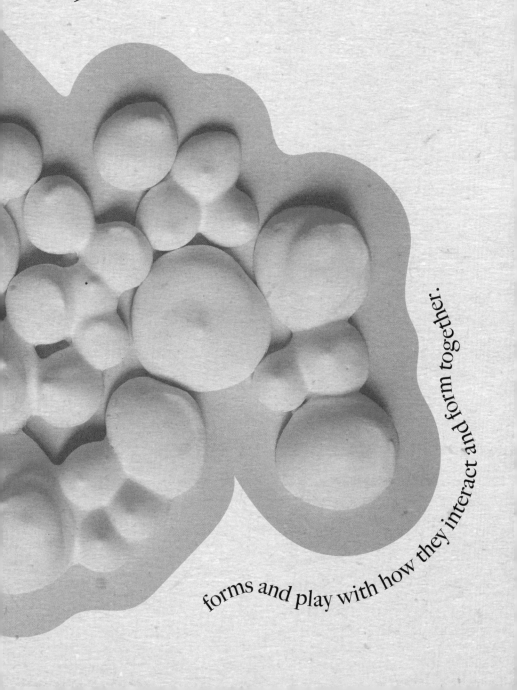

forms and play with how they interact and form together.

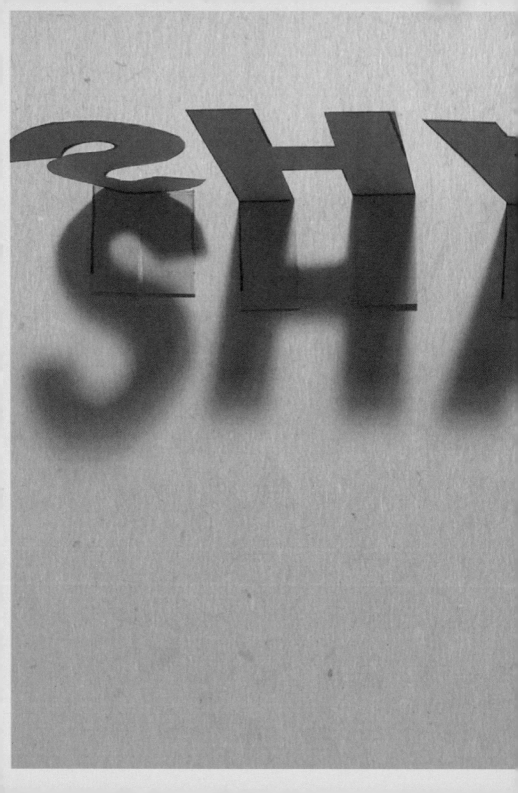

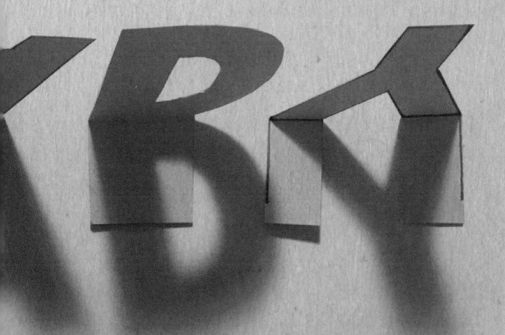

93. Cut out some words or a shape and place it in the sun or a lamp. Play around with the angles of the shadows.

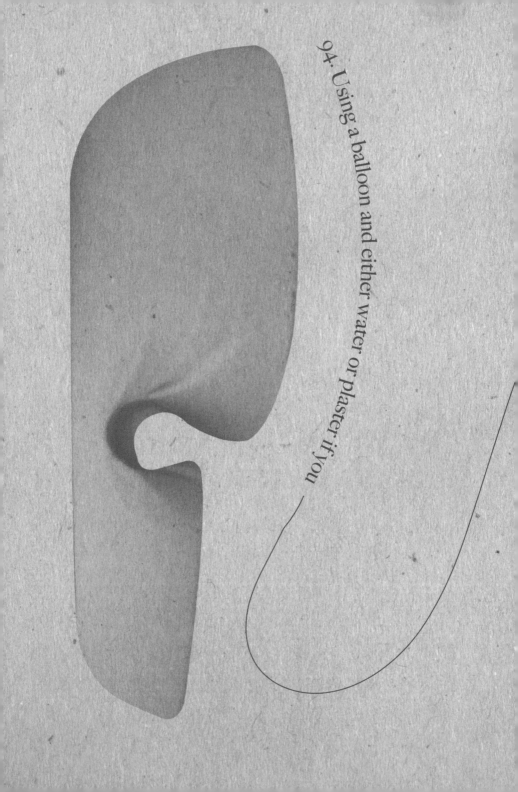

94. Using a balloon and either water or plaster if you

have it, create as many different shapes as you can, imitating organic forms.

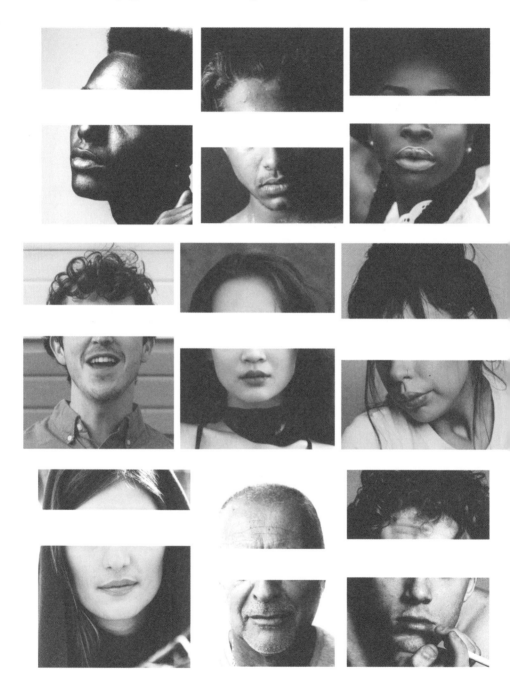

famous cartoon character eyes.

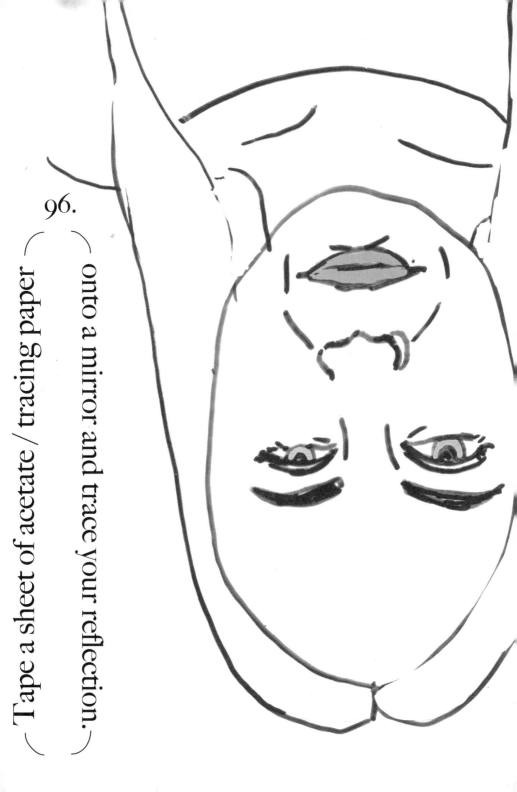

96.

Tape a sheet of acetate / tracing paper onto a mirror and trace your reflection.

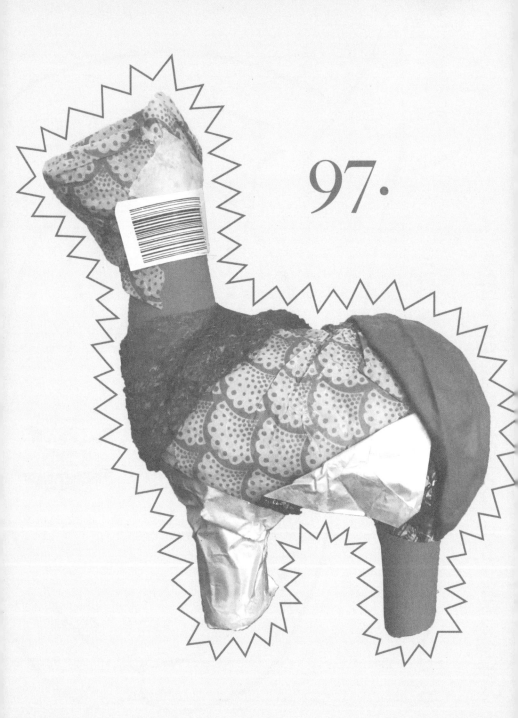

97.

Cover one 3D object completely in another found object (e.g. plasters, wrappers etc.). Have a photoshoot.

Create an eco campaign
poster using plants /
organic material.

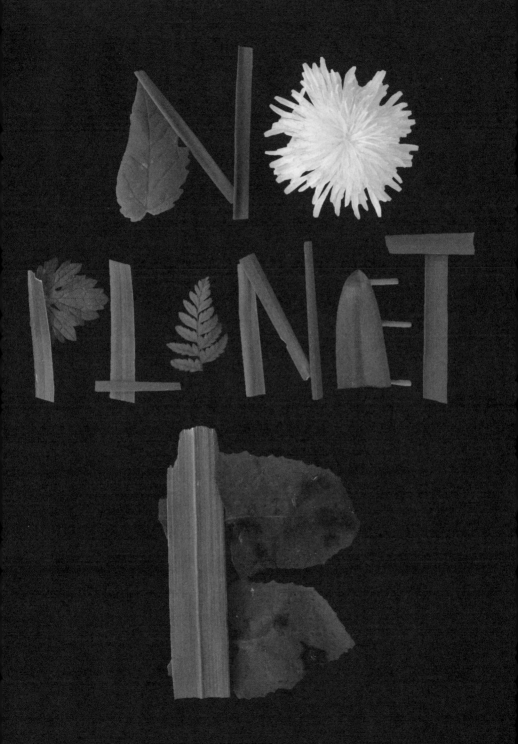

These are benches in Canada which offer protection for the homeless, as well as helping as you cover the top out

99. Make a piece of design that could serve an alternative, useful function - the sort of idea that wins awards.

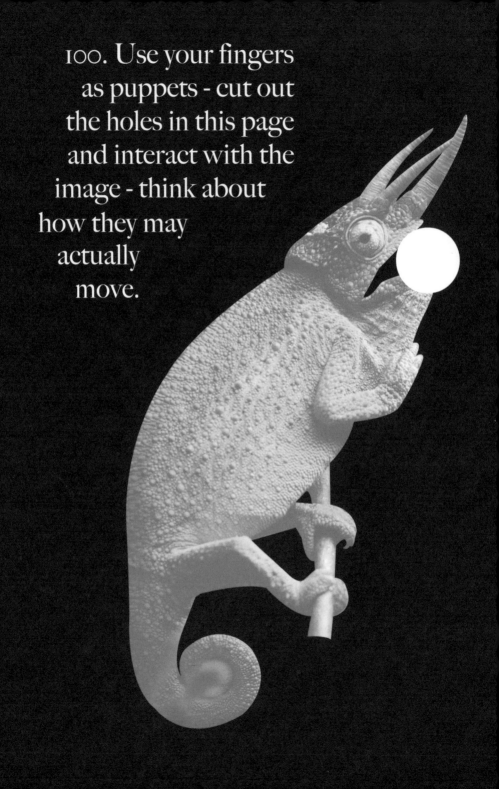

100. Use your fingers as puppets - cut out the holes in this page and interact with the image - think about how they may actually move.

Drip
water
onto
a
printed
out
image
and
re-draw
the
result.

101.

Put a mirror into a shallow bath and take *photos of the ripples/waves* on your reflection.

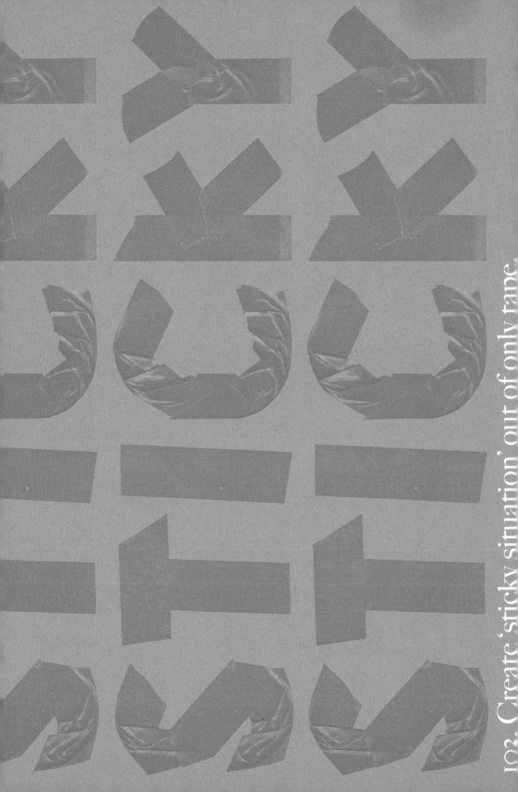

102 Create 'sticky situation' out of only tape.

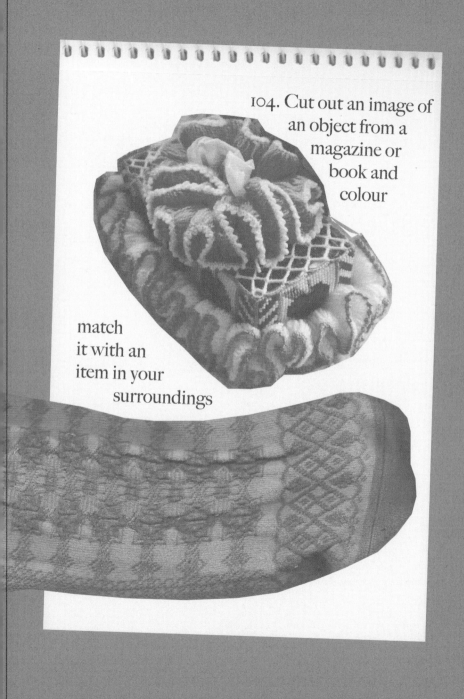

104. Cut out an image of an object from a magazine or book and colour

match it with an item in your surroundings

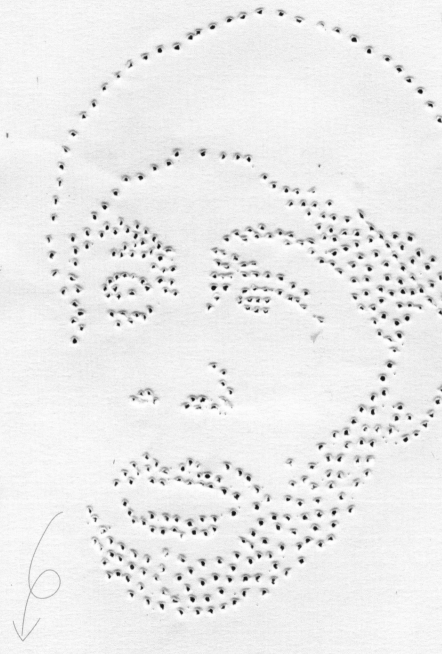

Create a tactile
image by poking holes through the page.
Like braille. Appreciate feeling the image.

You could also play with the use of shadow, by holding it up to a light or the sun. See what happens.

106.

Create yarn art, and allow it to lay itself on

a board or some card. See how it forms.

Make a print

107.

sheet plastic.

out of

scrunched up

108. Draw abstract shapes and forms with a wet ink / paint.
Let the colours merge, splat it - play with letting the image 'create' itself.

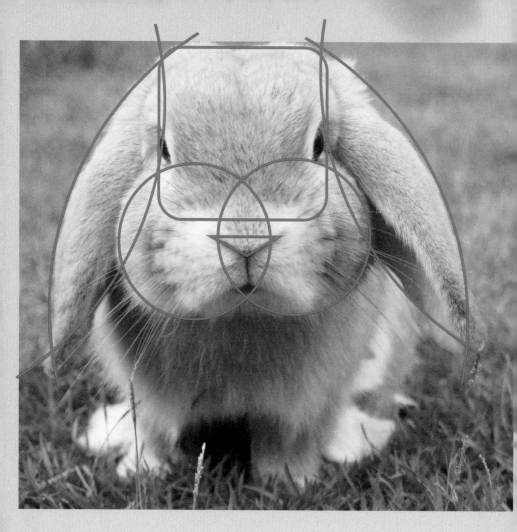

109.

Simplify an image, like the one above, forming the basic shapes of the face or profile of the image.

Using these basic shapes, create a simple logo with them. Try to keep the amount of different shapes to a minimum, less than 5.

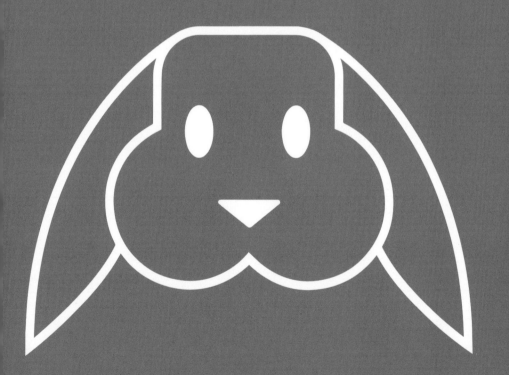

and watch the wind draw.

and sway, your own hair -

III. Make a portrait

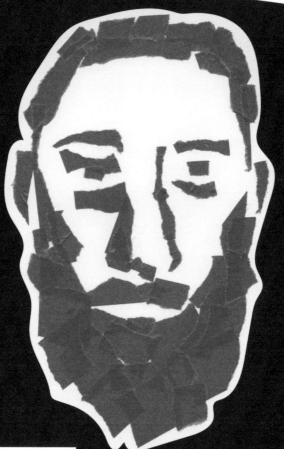

using only tape.

112. Design a poster that encourages people to add comments / drawings / opinions to. Compile them. Treasure them.

What would your poster ask?

I'd ask _____

I'd ask _____

I'd ask _____

I'd ask _____

I'd ask _____

I'd ask _____

I'd ask _____

I'd ask _____

II3.

Pick a song.	Now storyboard;	envision;
screenplay;	how it could	be used as an
overlaying track in	3 different	film genres -

horror,

comedy

and drama.

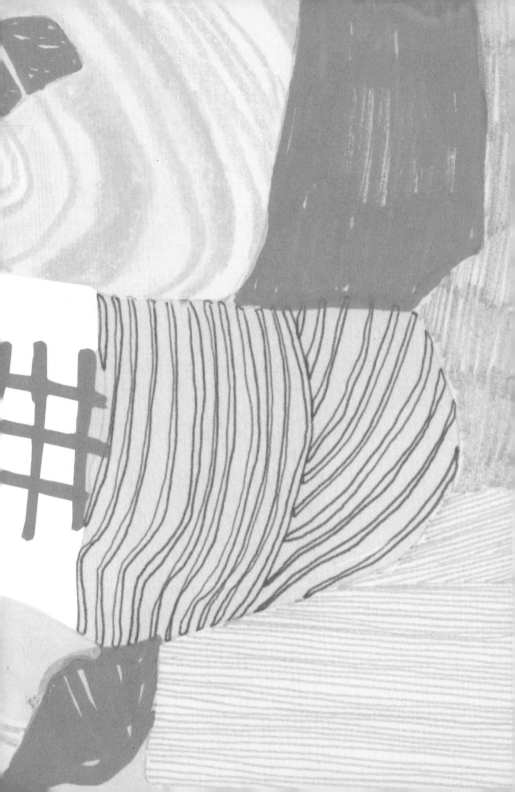

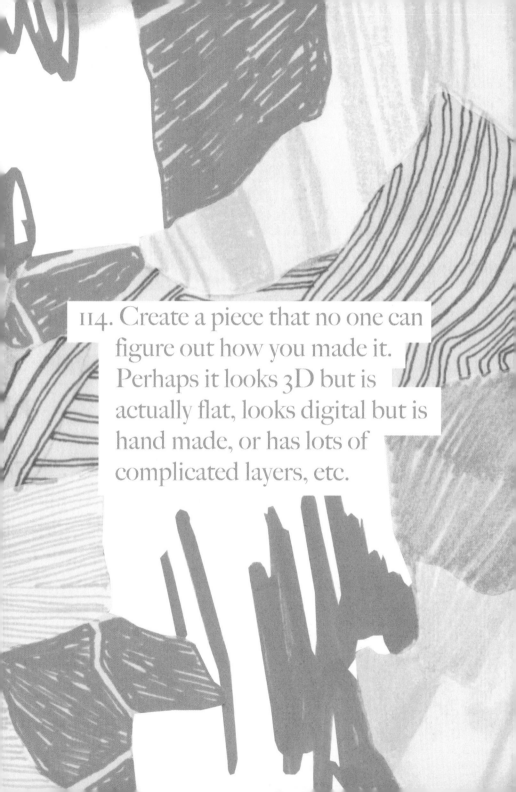

114. Create a piece that no one can figure out how you made it. Perhaps it looks 3D but is actually flat, looks digital but is hand made, or has lots of complicated layers, etc.

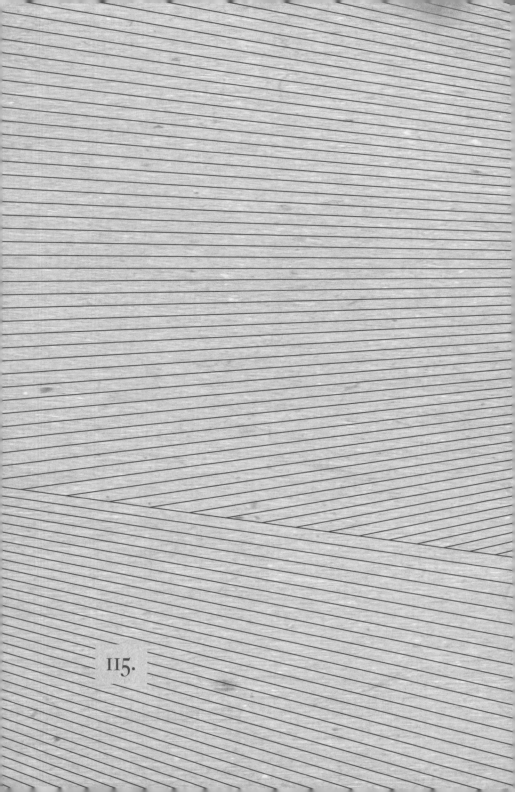

115.

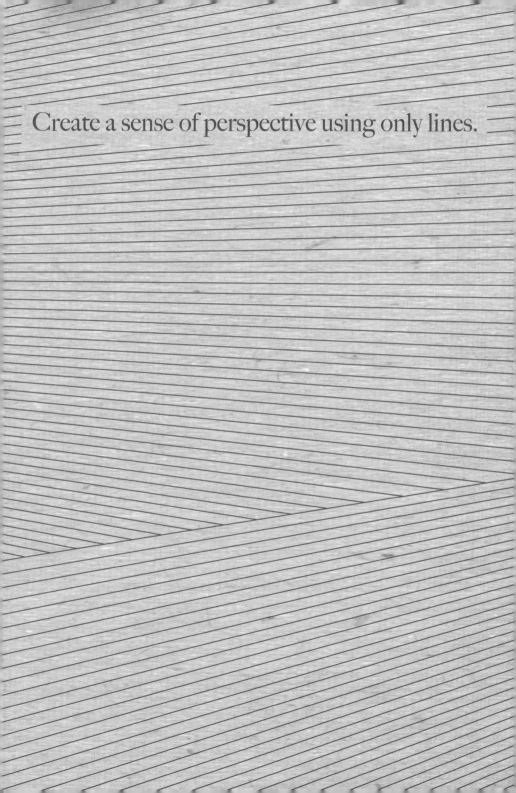

Create a sense of perspective using only lines.

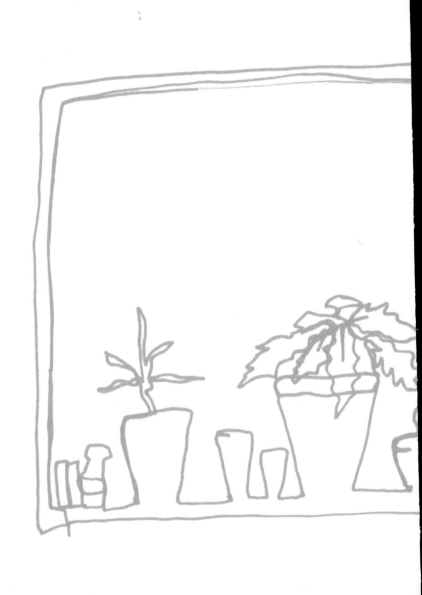

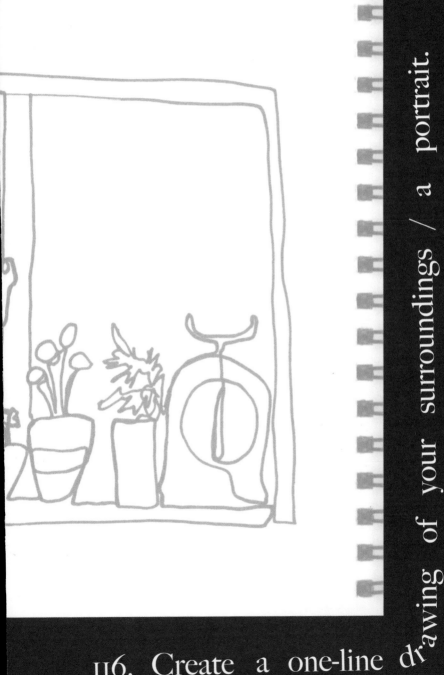

116. Create a one-line drawing of your surroundings / a portrait.

117. Alter the perspective and texture of each
image by the descriptive word beneath it.

In steam / a cloud

Underwater

Through a fish-eye lens

Write the book you want
to read. }

118.

So what was that all about? Well, here's what.

Each task has a meaning or an application beyond the book. Hopefully, they've opened up your creativity, and given you more confidence in projects and ideas you've worked on since. Maybe they've served as inspiration or something to give you the kickstart you needed.

Here's the relevance to each one, which you can use to reflect on their purpose and think about how you can apply those skills in the future, should you need to revisit them. They may even give you a fresh perspective on a brief you otherwise wouldn't have considered certain techniques for.

The Big List.

To understand immediate connections between emotions and marks. Can be used in any from of creative practice where a certain feeling is to be conveyed visually.

To connect the viewer to the story visually. Can be used to engage a viewer as well as give context to the story through the typography.

To experiment with perspective in type.

. To experiment with the structure and formation of type. To reimagine the shapes we accept and find new ones.

To gather an understanding for reimagining an image outside of it's context, as well as general grasp of constructing an image. Can be used in a project where separate imagery needs combining.

. To start to understand the construction of type.

. To experiment with uncontrollable circumstances - to begin to 'let go' creatively.

. To experiment with creative associations and to understand personification creatively.

. To understand bodily movement. This could be used for animation, or understanding a subject in a piece.

). To disassociate words with what's written and instead understand them purely as a pattern or code, such as colours.

. To play around with the possibilities of form and shape, as well as gain an understanding of them.

2. To completely detach from a piece and not allow for any sense of detail or time consumption.

3. To be able to create from reduced resources and experiment with minimalist design.

4. To experiment with non-traditional materials, which could spur further experimentation.

5. To experiment with typography whilst using non-traditional and more challenging means of creating it. To play with your perception and imagination.

5. To work from a source and allow for yourself to explore various creative avenues / perspectives.

7. To play with imagery and allow for a child-like imagination and creation in work. Can be utilised in any form of creation and allows for your mind's eye to wander.

8. To play with distortion and experiment with unfamiliar lines and form.

). To understand the construction of type and work in a minimalist way.

o. To work with minimal shapes provided and create an image from them.

1. To reimagine photography and delve into the surreal.

2. To begin a drawing practice to enhance observational skills.

3. To experiment with how movement can alter a material or image.

24. To experiment with distortion combining the digital and physical.

25. To experiment with your understand of form and shape based on an imagined image. To let go of perfectionism.

26. To test your understanding and construction of familiar images.

27. To play with uncontrolled imagery and create a story or scene.

28. To begin to play with creating a sense of urgency or information within an image.

29. To play with the hand manipulation of film.

30. To experiment with scaling up an image and working with maximised textured.

31. To play with the often unobserved or singled-out in an image. Then consider this in hindsight when looking at ima ry.

32. To play with typographic execution, as well as what different forms of type convey - emotions, how they could relat amongst imagery, etc.

33. To play with the textures of an old pen and consider how other similar materials may react for a piece.

34. To consider the construction of an image with complex and uncontrolled shapes.

35. To play with reimagining of an image using print.

36. To play around with layering to create an image.

37. To test out zoom levels within an image.

38. To combine images with words and meaning.

39. To test out more radical art forms, and gain an appreciation for guerrilla creativity.

40. To find lettering within common sights and environments. Allowing you to be hyper observant, and inventive in necessity.

41. To play with shape and tone within given shapes to explore new imagery.

42. To play around with methods of hand manipulation of an image.

43. To play around with type as a method of tone or colour.

44. To understand dimension of a shape with only the 2D to reference.

45. To play around with the direction of line to create an abstracted image.

46. To transform shapes into alternative images and therefore meanings.

47. To play around with dimension and perspective within type.

48. To test out alternative means of building an image. Could be used in various abstract art forms as well as logos, et

49. To play with line and direction.

50. To understand visual metaphors and the connections that can be evoked from them.

. To change your perception on line by creating an image with type.

. To make relevance between images and the emotions they evoke to an unrelated scene. Could be used for screenwriting.

. To transition between unrelated images. Mostly helpful for animation.

.. To play again with movement in painting.

. To research the transition of time and the effect it has on materials, to consider new forms and colours from this process.

. To play with line and form in the restriction of the size and physical properties of paper.

. To play with uncontrolled imagery and use your imagination to make sense of it.

. To construct type within given lines. Used most popularly in poster design.

. To re-contextualise shapes such as circles under the pressure of quantity.

. To be able to translate sound into movement, an exploration into synesthesia.

. To be able to give context to a complex and incredibly abstract image.

. To gain further grasp of your imagination within perspective and context.

. To play with texture and mark making within an image and to then build one with these skills.

. To consider abstract environments and play with a childish imagination.

. To reimagine given shapes into typography for use on posters or artwork.

. To play with abstraction and minimalism to create detailed imagery.

. To reimagine corporate logos into an image, mostly to test how well you can remove the context of a designed shape image to create an entirely new one.

. To experiment with image creation within tight, minimal restrictions.

. To give context to attract shapes. This is essential in art criticism and understanding.

. To experiment with childish imagination as well as take an image into a new context.

. To lose control and precision of an image and invent this into something new. To always see the best of an image that may otherwise be considered 'ruined'.

. To create a common drawing practice whilst considering the subjective idea of opposition.

. To work on a larger scale of producing imagery within the restrictive bounds of paper.

. To play with layered imagery in a 3D sense.

. To experiment with collage and surrealism, and experiment with how fun it is!

. To experiment with abstract line and form.

. To play with guerrilla design and advertising.

. To translate an image into type and create using letters.

79. To have an understanding of observational creativity and collage.

80. To create uncontrolled patterns and forms.

81. Experiment with 3D attraction in portraiture.

82. To test out basic understanding of facial expression and emotion.

83. To play with layers of an image and experiment with colour layers. Can be useful when approaching a screen print or risograph print project.

84. Furthering experimentation with perspective and distortion.

85. To play with alternative materials and method of mark / print making.

86. To experiment with the correlation between meanings and imagery in an inventive and crude sense.

87. To make connections between your daily life and a representative object. To then consider where else can objects be symbolic or representative.

88. To play with using objects as a form of tone or colouring.

89. To construct an image using abstracted objects.

90. To experiment with a sense of urgency and appeal in design.

91. To play with visual comparisons and humour.

92. To play with dimension in abstract image creation.

93. To play again with shadow as a final image. Could be used commercially for signage, way finding, etc.

94. To understand organic forms and appreciate their creation and construction.

95. To understand how eyes alone provide personality and character.

96. To play with perspective and test portraiture skills.

97. To disturb the context of an object and give it a new form and meaning.

98. To play with typography through organic forms.

99. To be functional in design and think cleverly about practicalities.

100. To play around with movement in puppets, useful for animation as well as creative down-time.

101. To test out the uncontrollable circumstances in creativity.

102. To play with organic distortion through water.

103. To test out type creation through tape and hopefully experiment with other materials.

104. To gain an appreciation for colour and forcing yourself to understand colour tones and matches.

105. To play with different forms of image creation.

. To play with line and shape using alternative methods.

. To play with different methods of mono printing / printmaking. Test with other materials.

. To play with the interaction of materials.

. To understand the basic shape and form of an image to create a simplified version. Useful in logo creation.

. To play with organic creation, appreciate natural forces and physics.

To play with portrait creation through alternative means - like the tape type, test other materials.

. To explore research into creativity and taking suggestions. Multiple minds!

To play with sound association to imagery through familiar songs into new contexts.

. To experiment with new methods of creation and being innovative within creativity.

. To play with line and perspective.

. To play with drawing within the restriction of single-line.

To play with understanding of visual perspective and texture without physical reference.

. To, well, be the next creative author.

told ya

Ultimately, keep experimenting and testing your creativity. Go further, make discoveries, and make art!